Gustave Courbet: Exposed

Edited By Lacey Belinda Smith

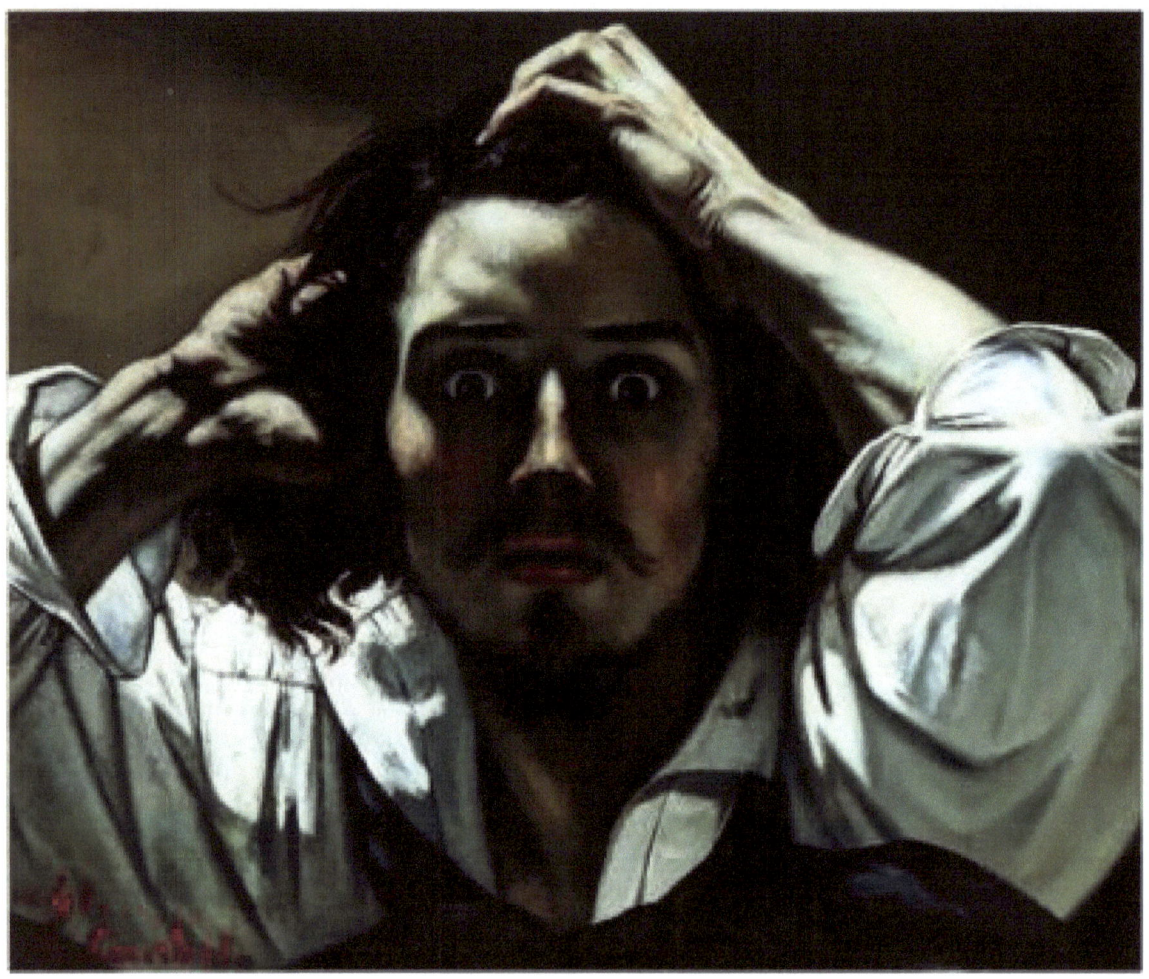

Gustave Courbet (1819-77) was a French painting and sculpture. He started and dominated the French movement toward realism. Best known as an innovator in Realism (and credited with coining the term). He bridged the gap between Romanticism and the Impressionist school of painters.

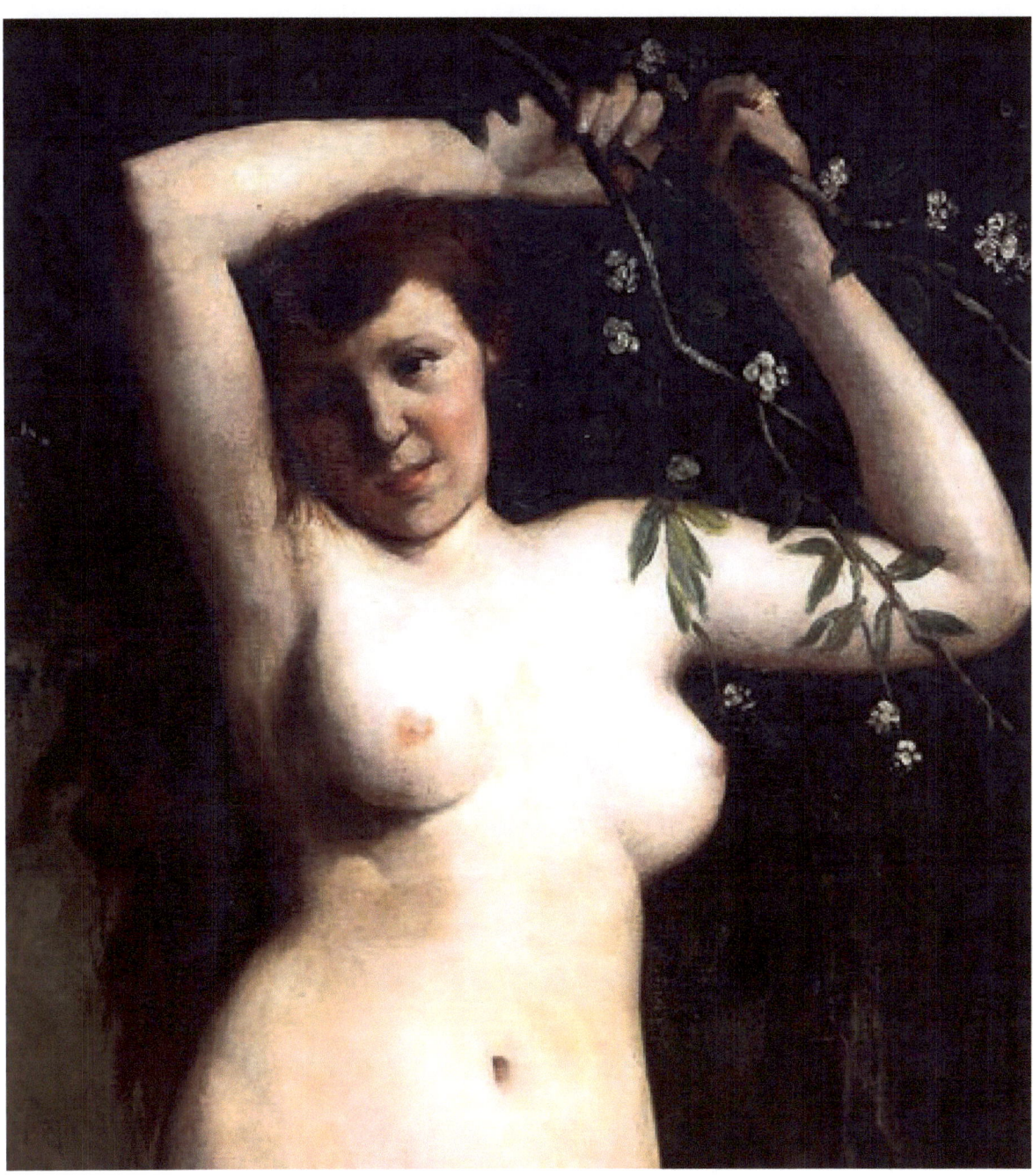

Torso of a Woman

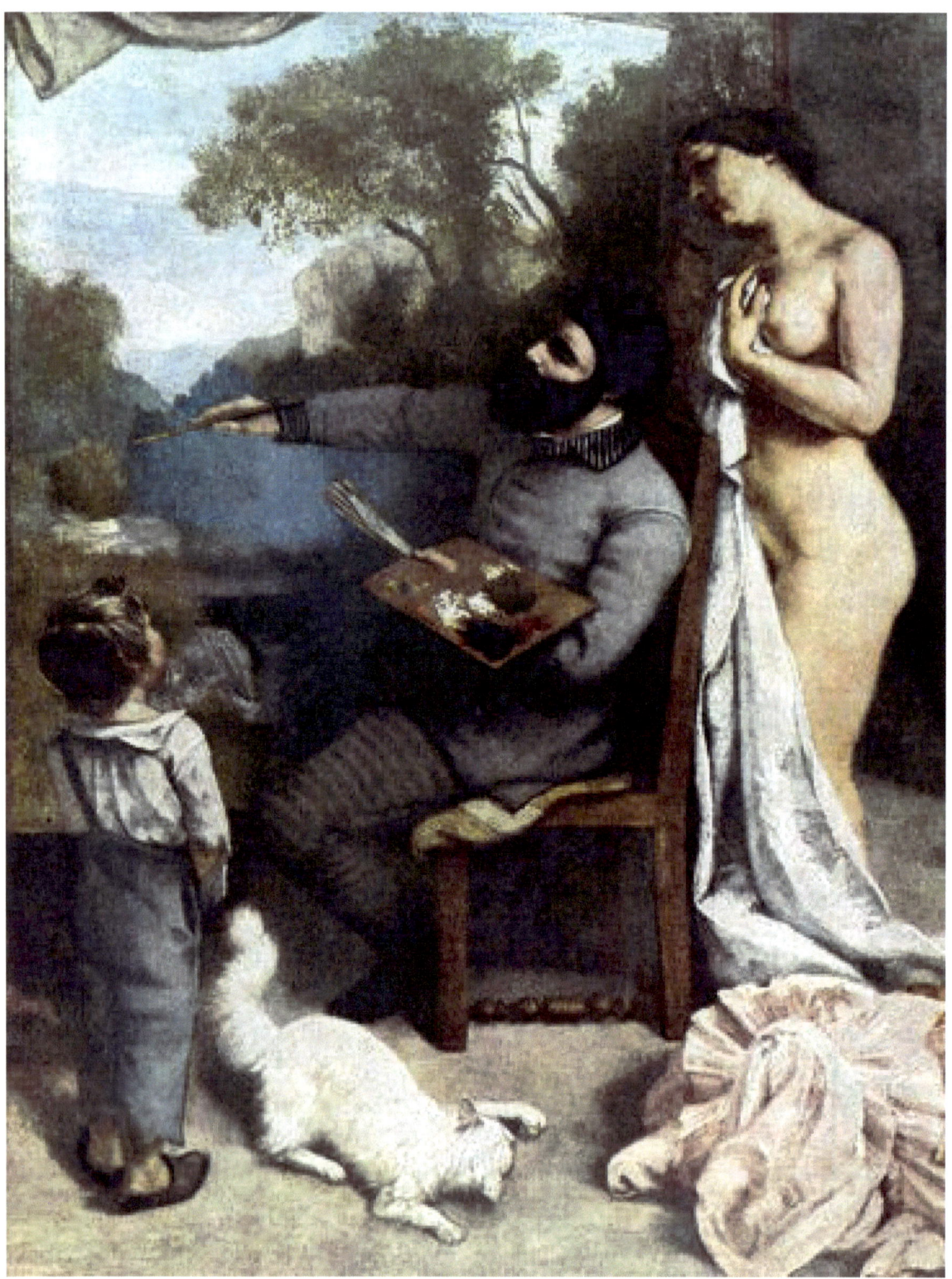

The painter's atelier, Detail

Femme Nue

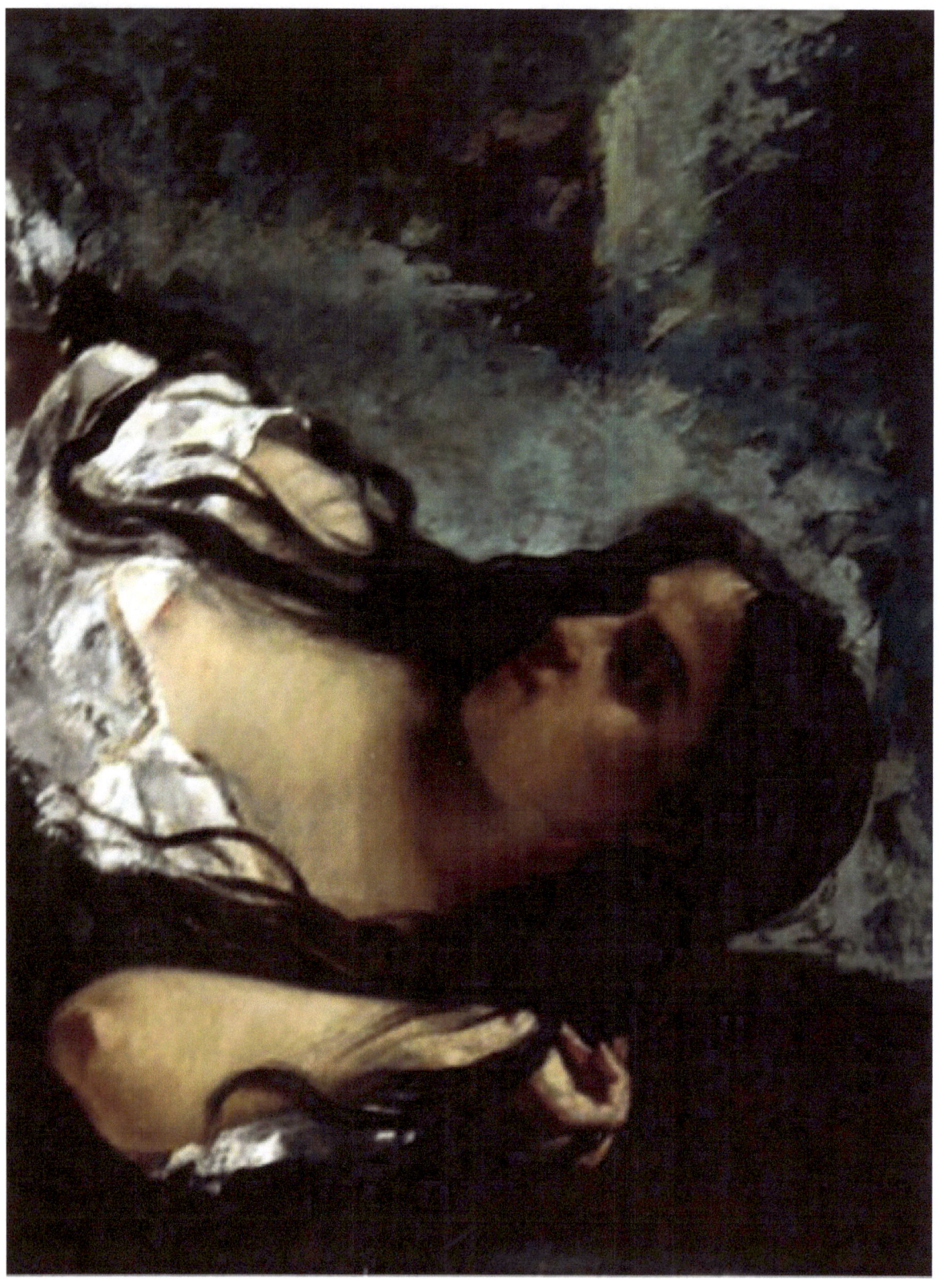

Gypsy in Reflection

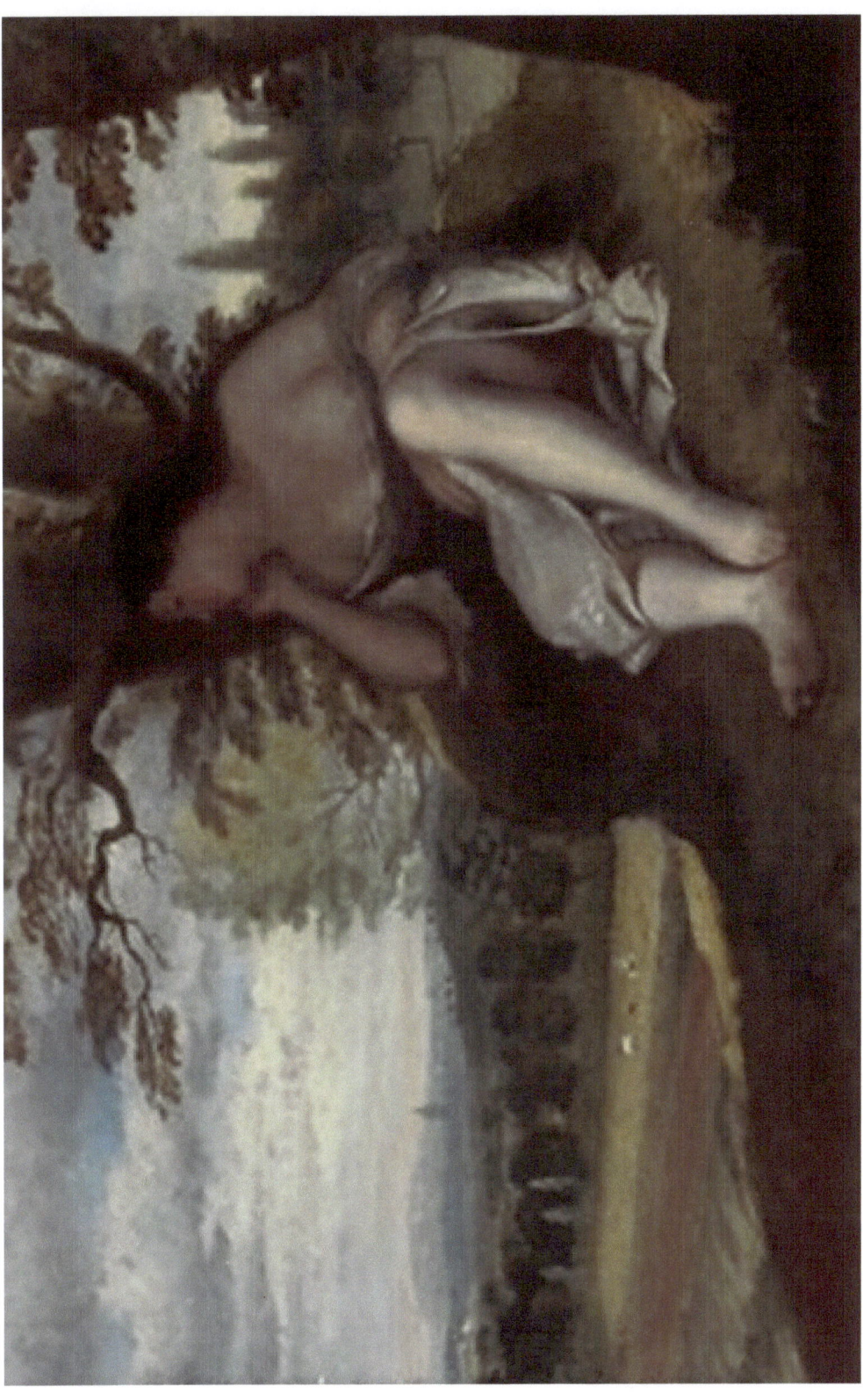

La Sieste 2

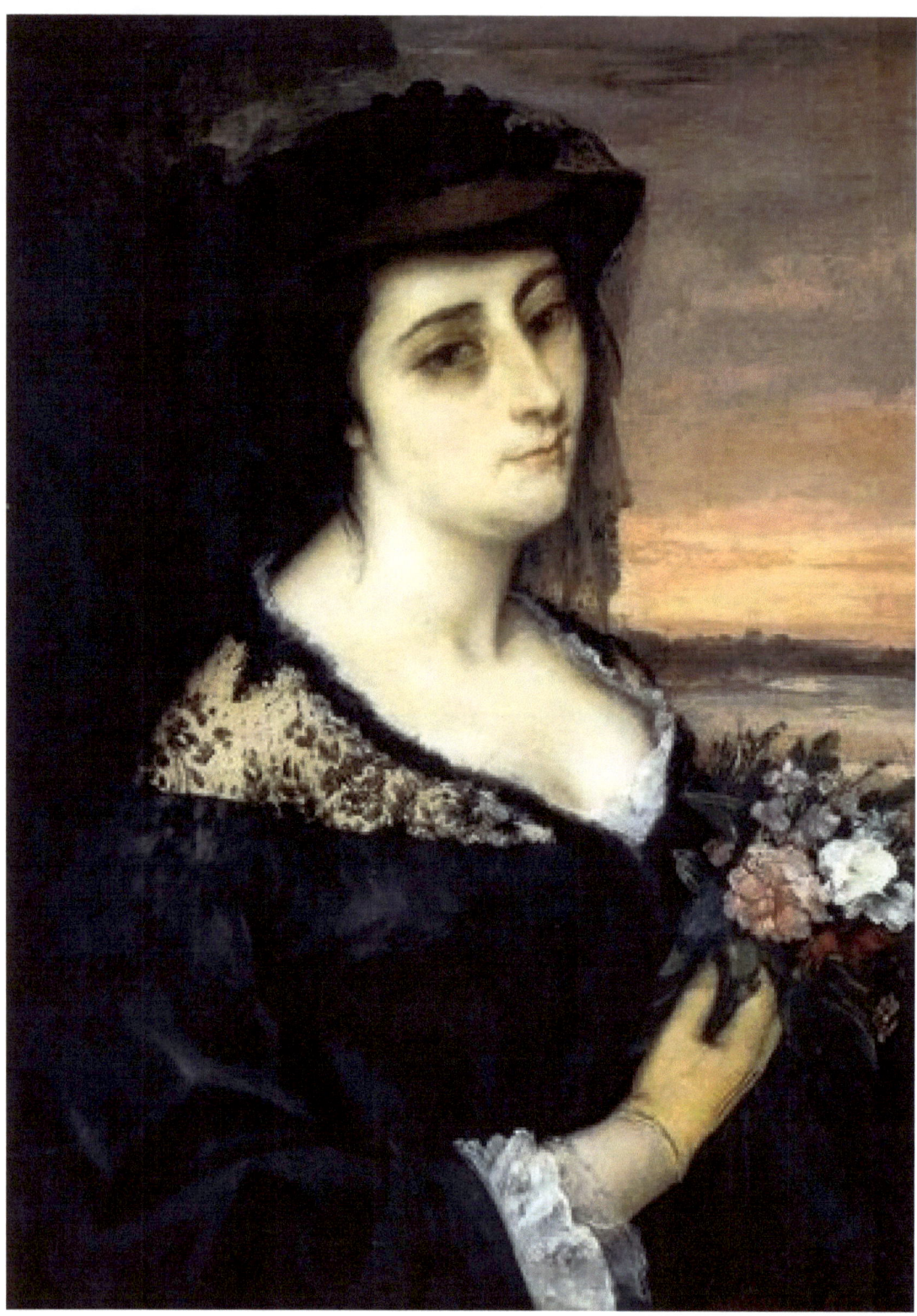

Portrait of Laure Borreau

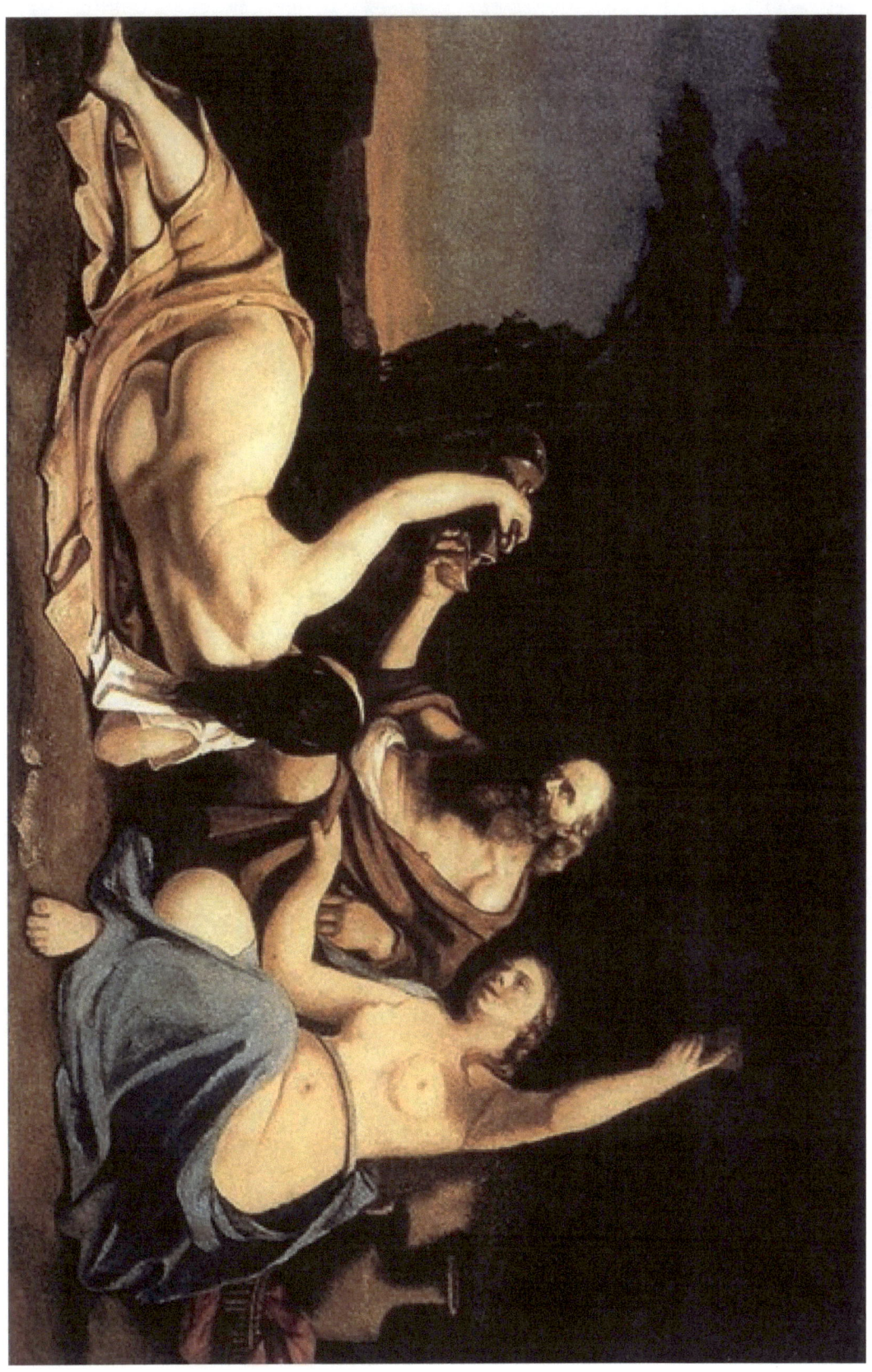

Lot and His Daughters—1844

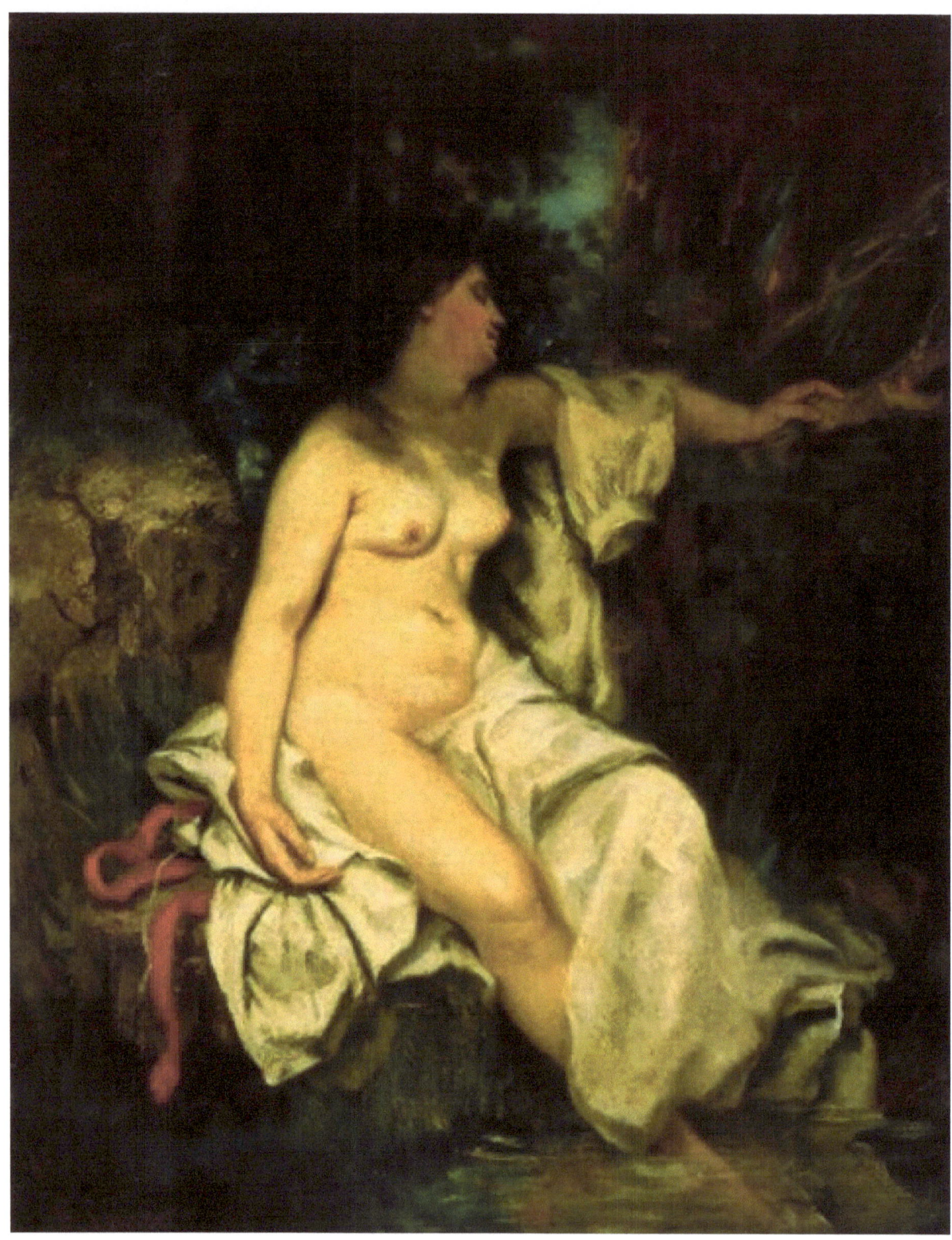

Bather Sleeping by a Brook
Romanticism

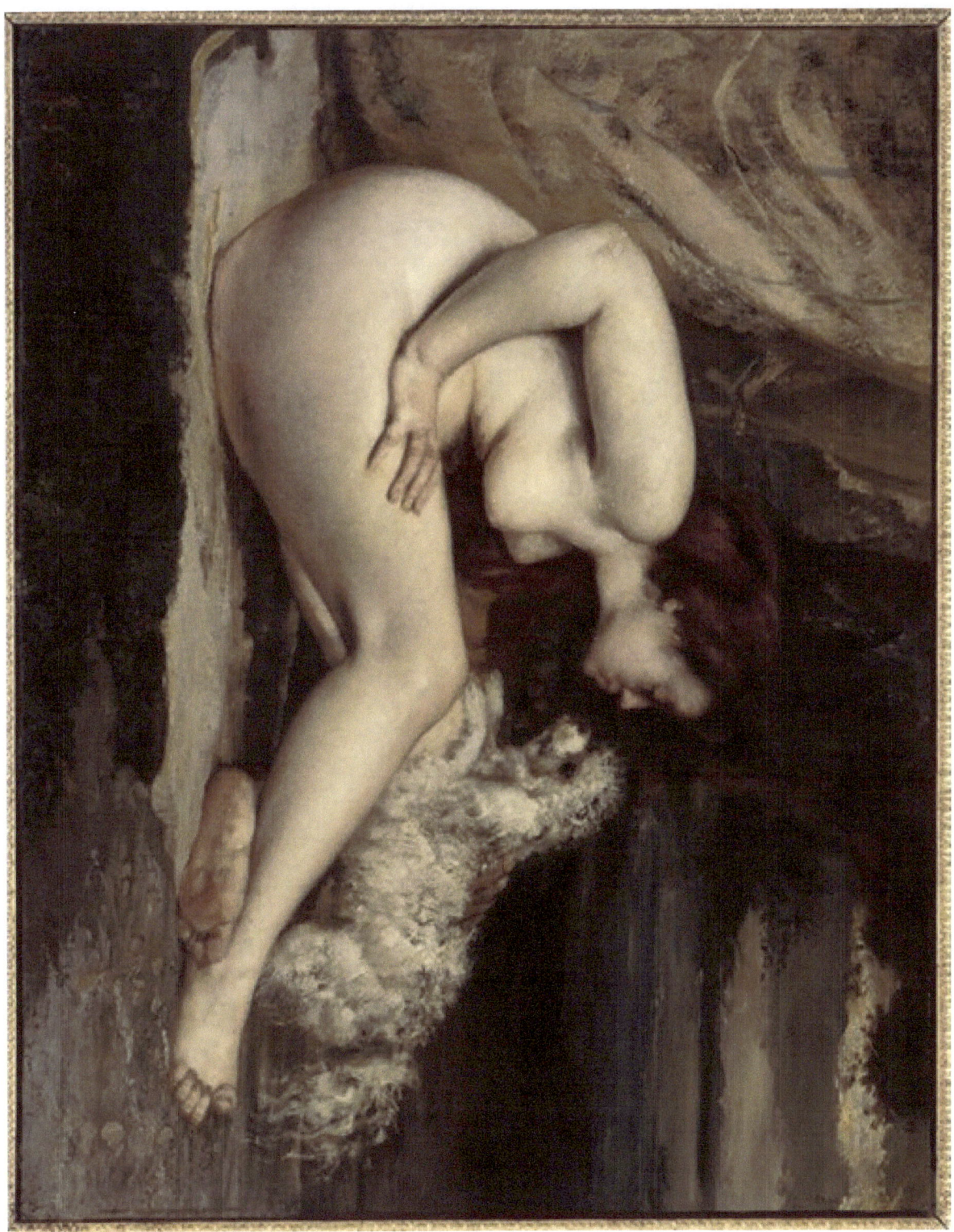

Female Nude with a Dog (Portrait of Leotine Renaude)
Realism

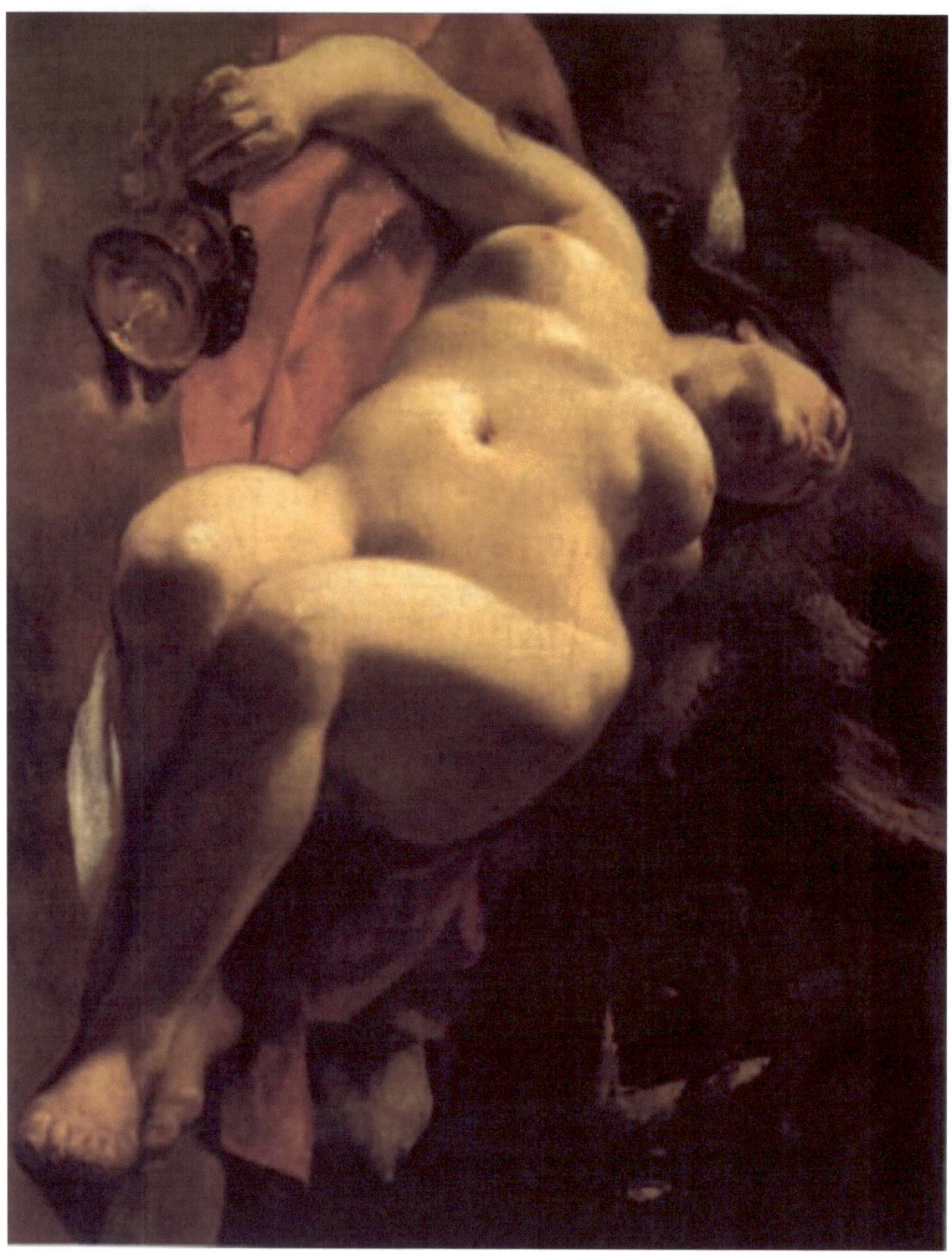

La Bacchante

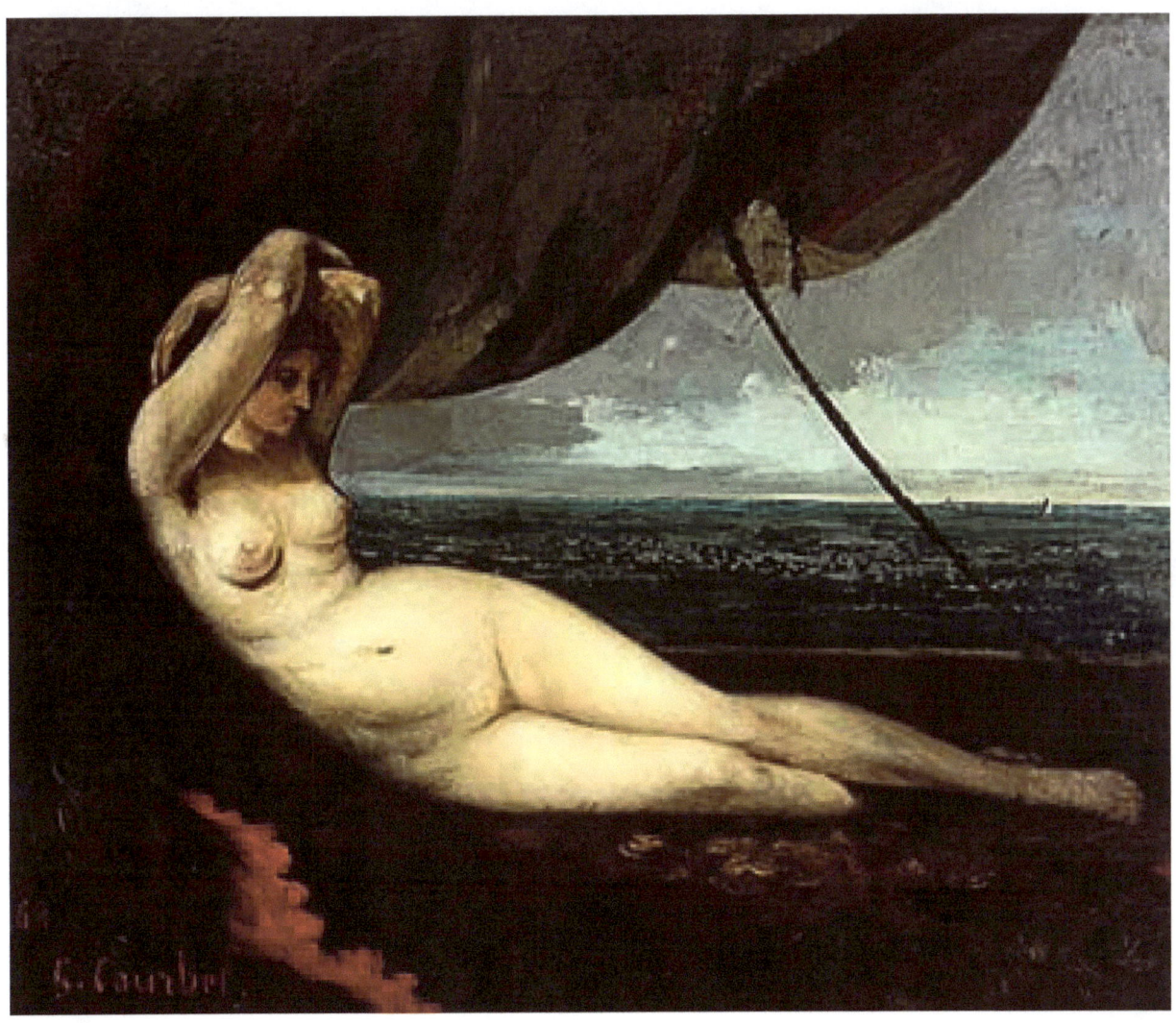

Nude Reclining by the Sea
Romanticism

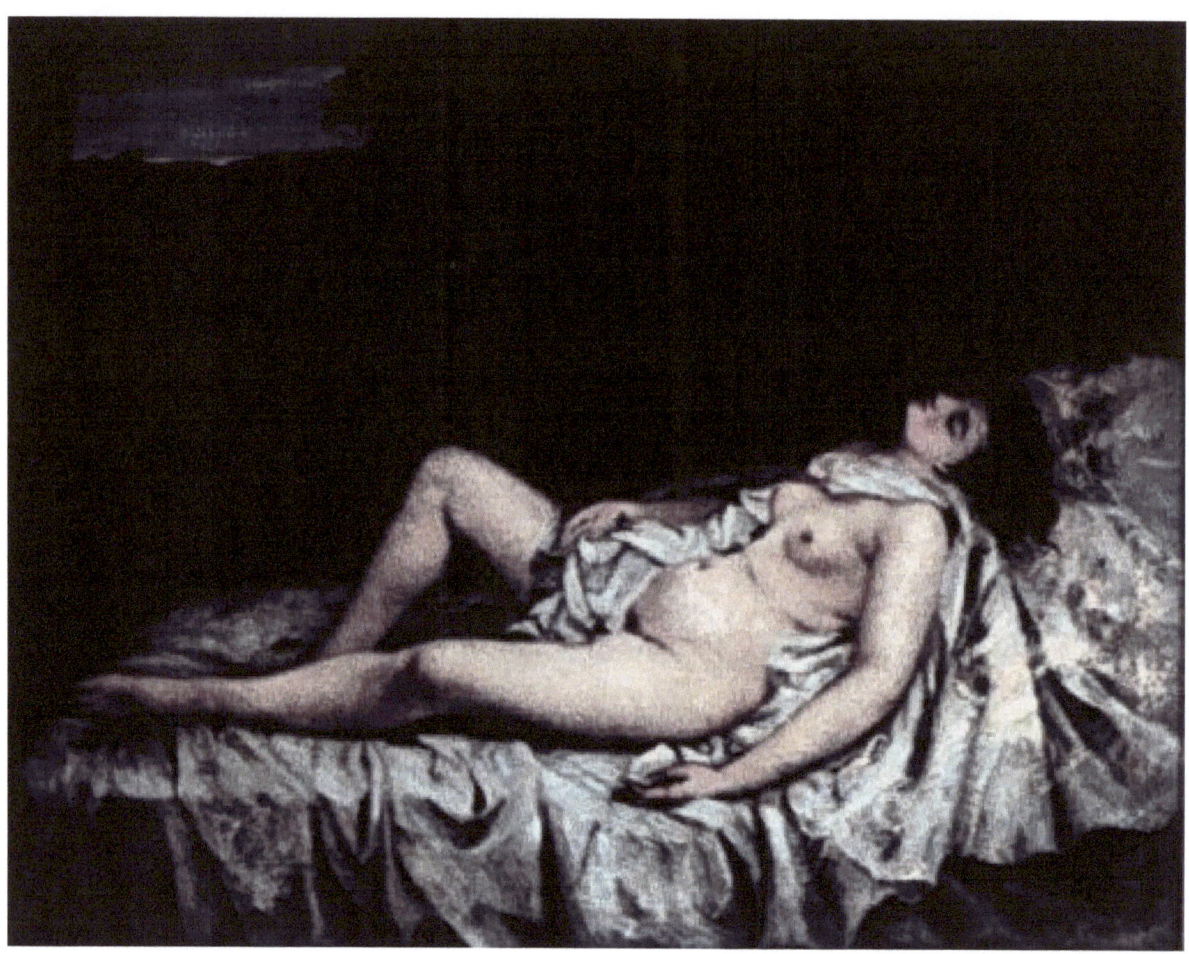

Reclining nude

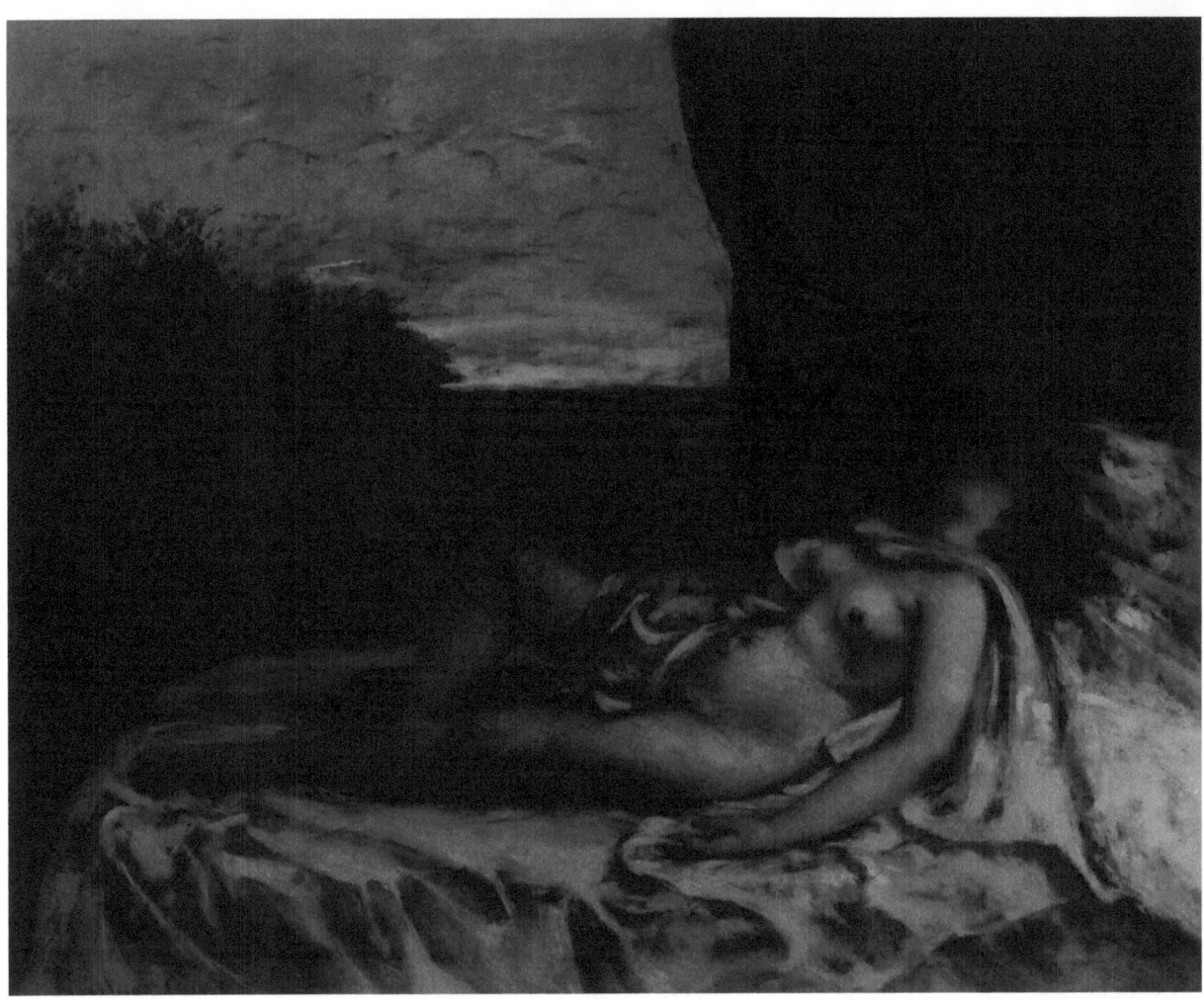

Sleeping Nude

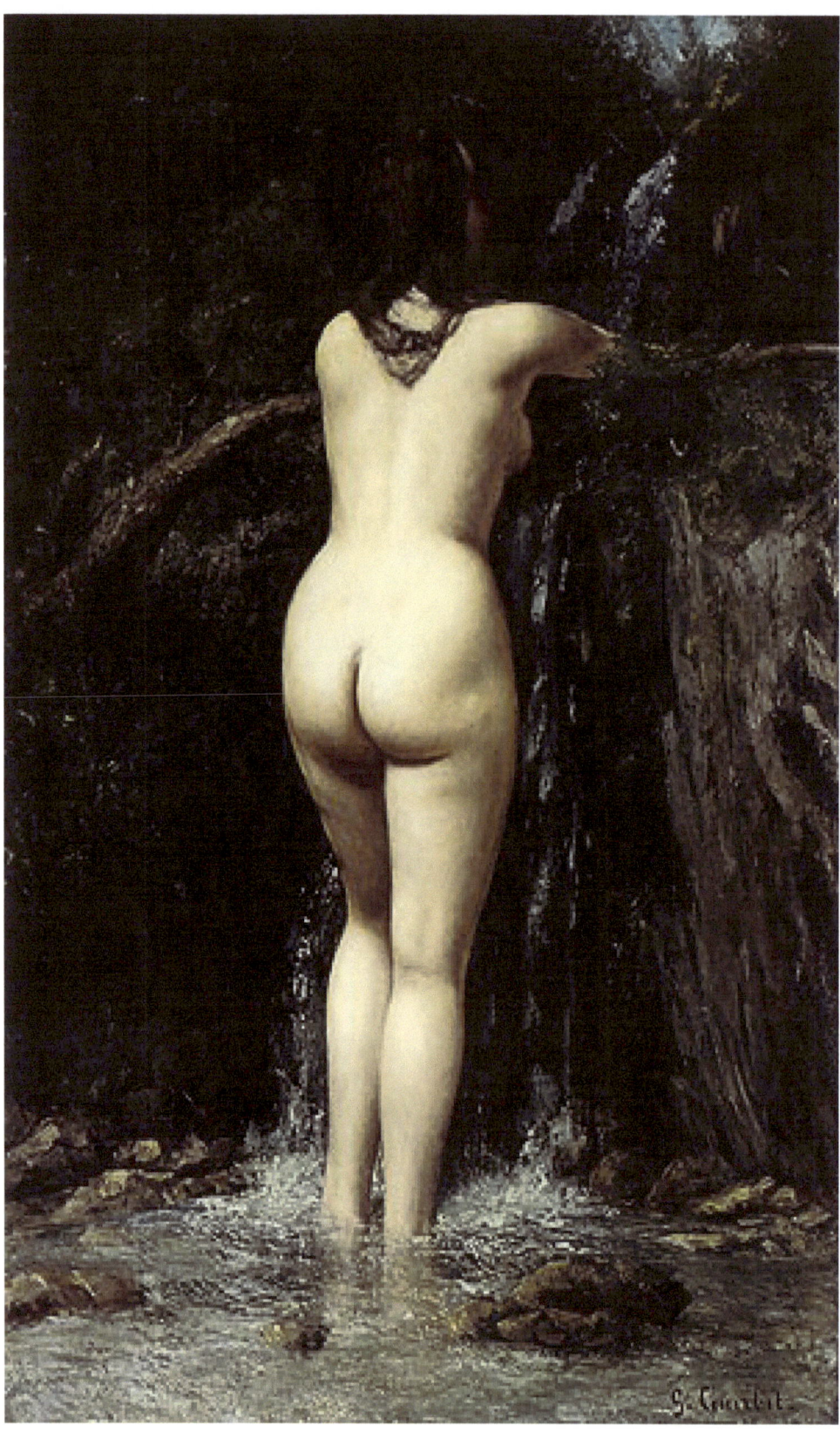

The Source

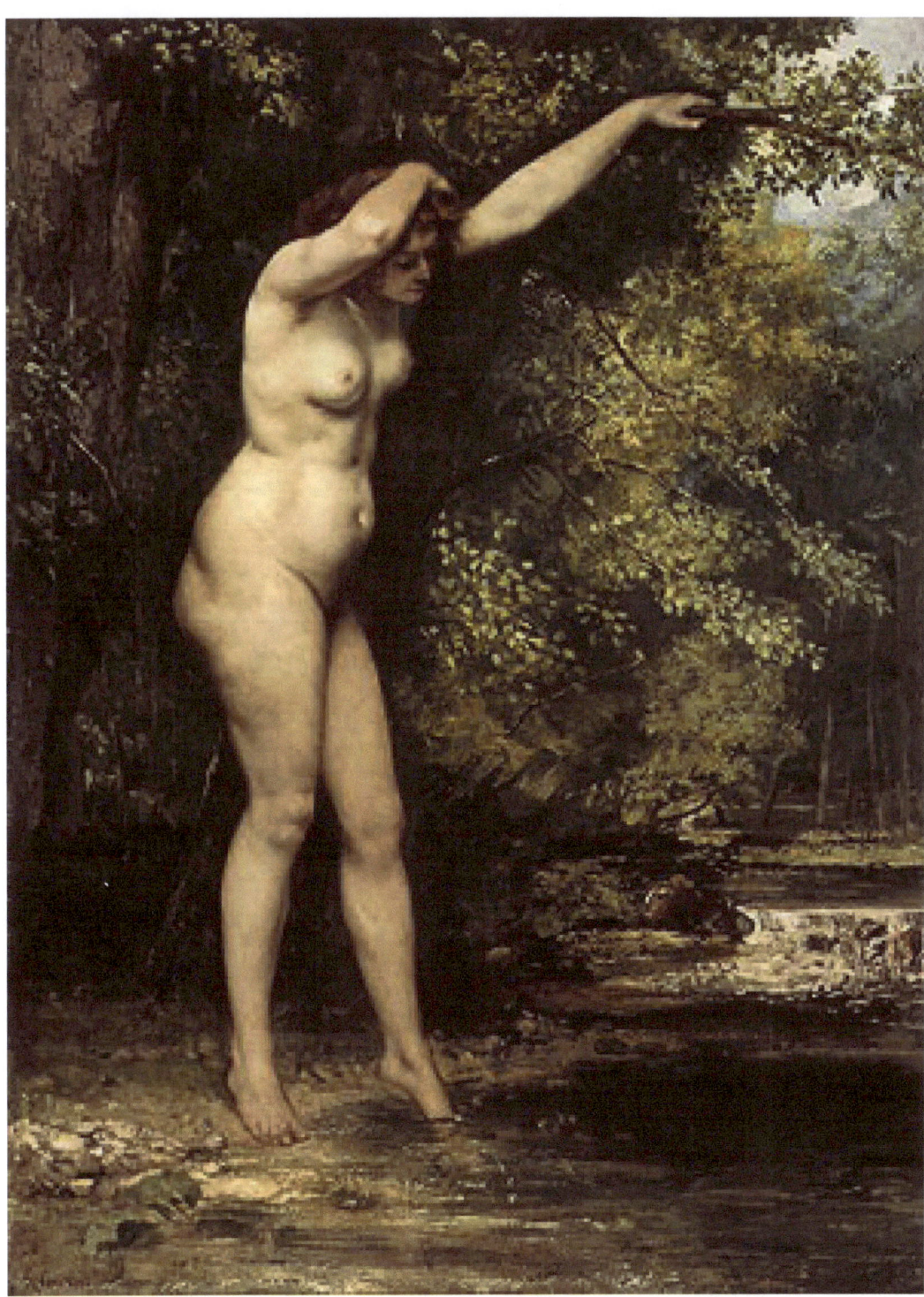

The Young Bather

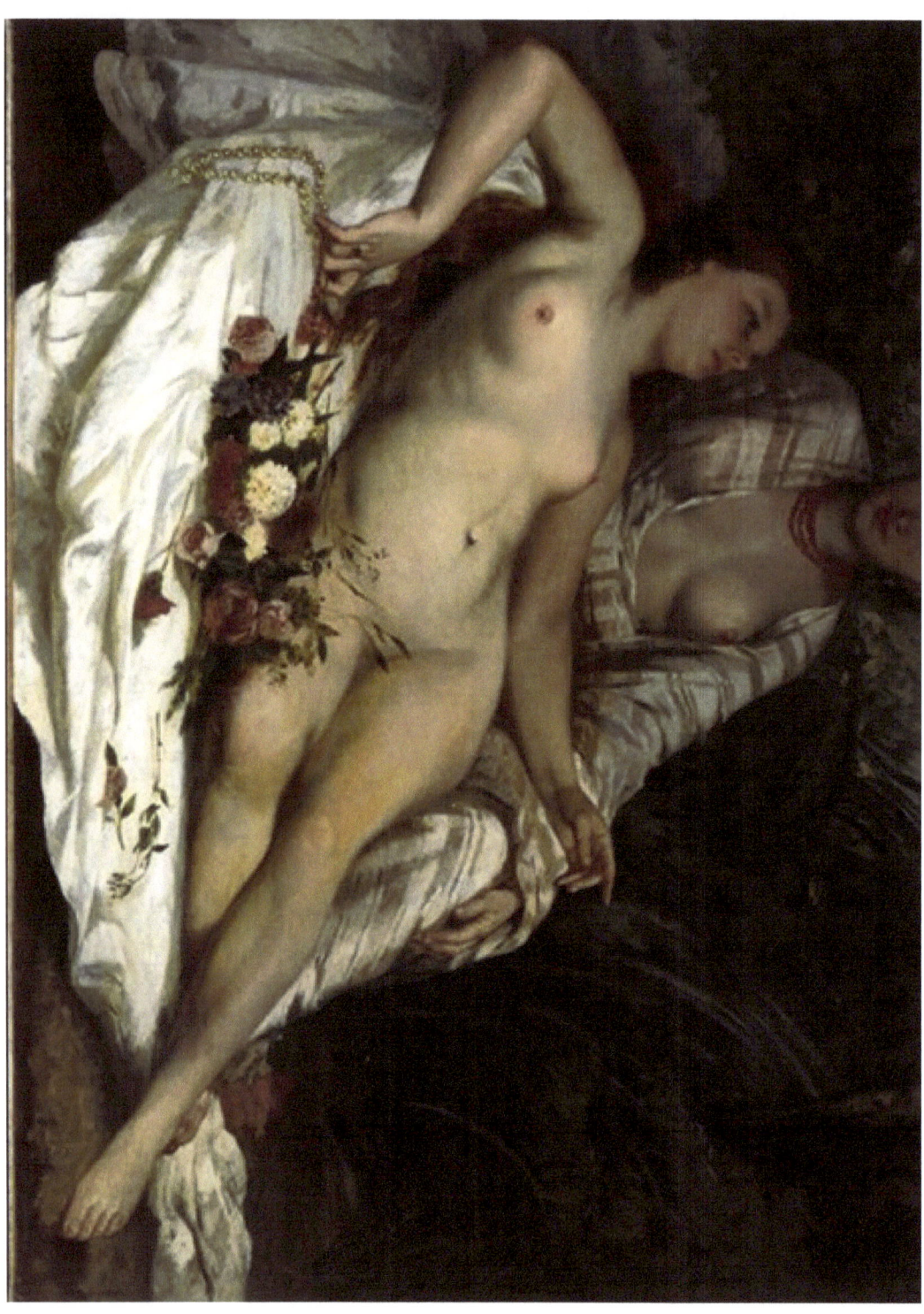

The Bathers--1858

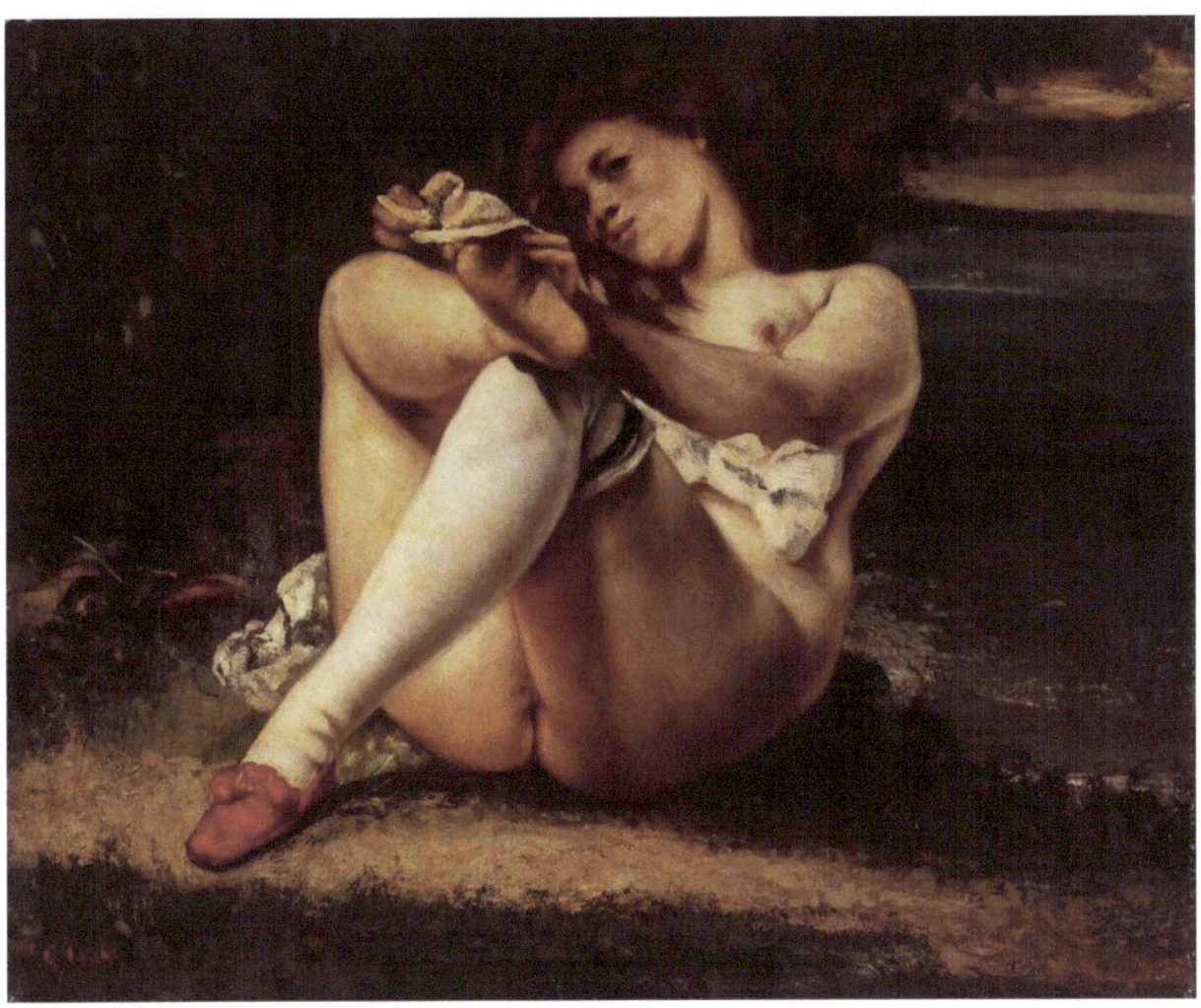

Woman with white stockings

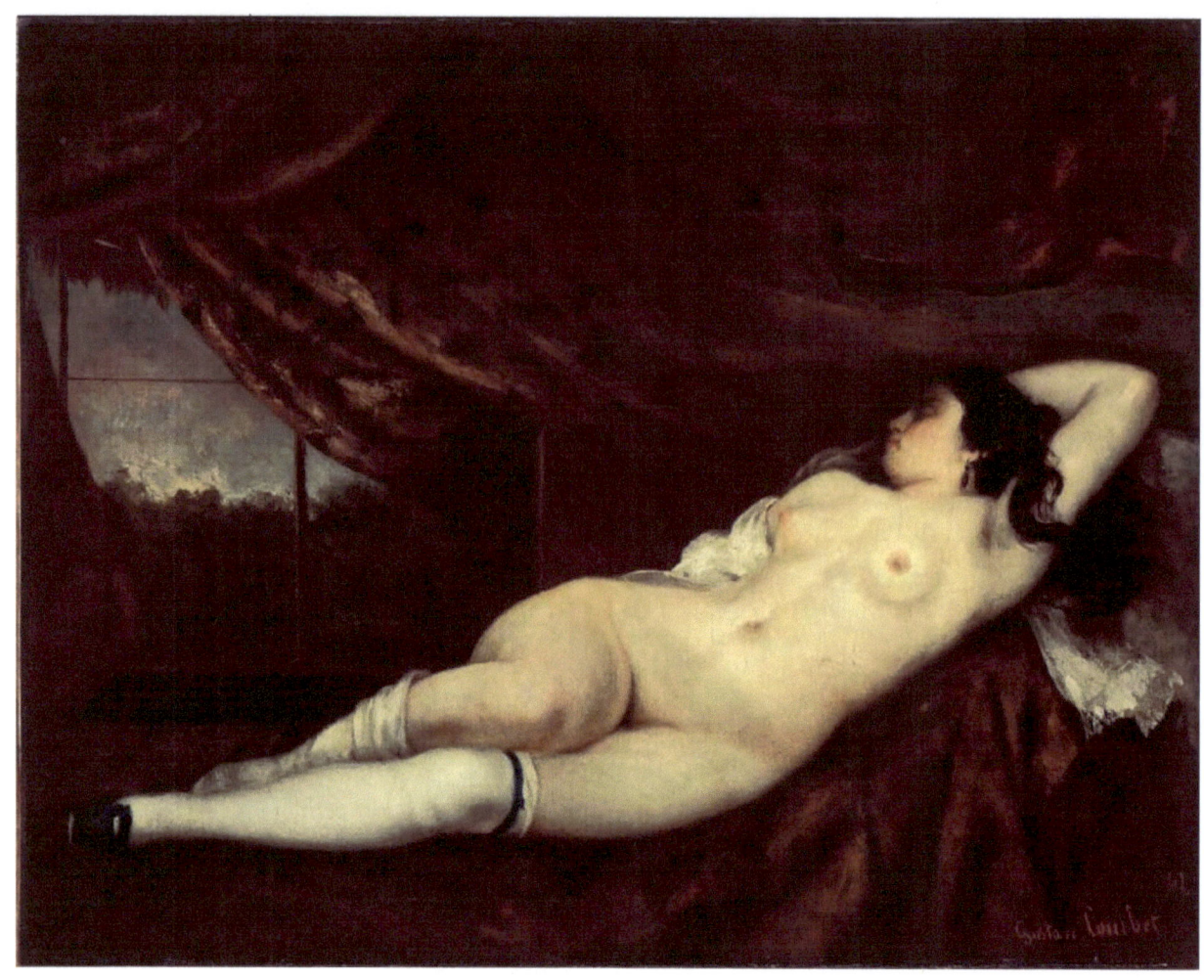

Sleeping Nude Woman

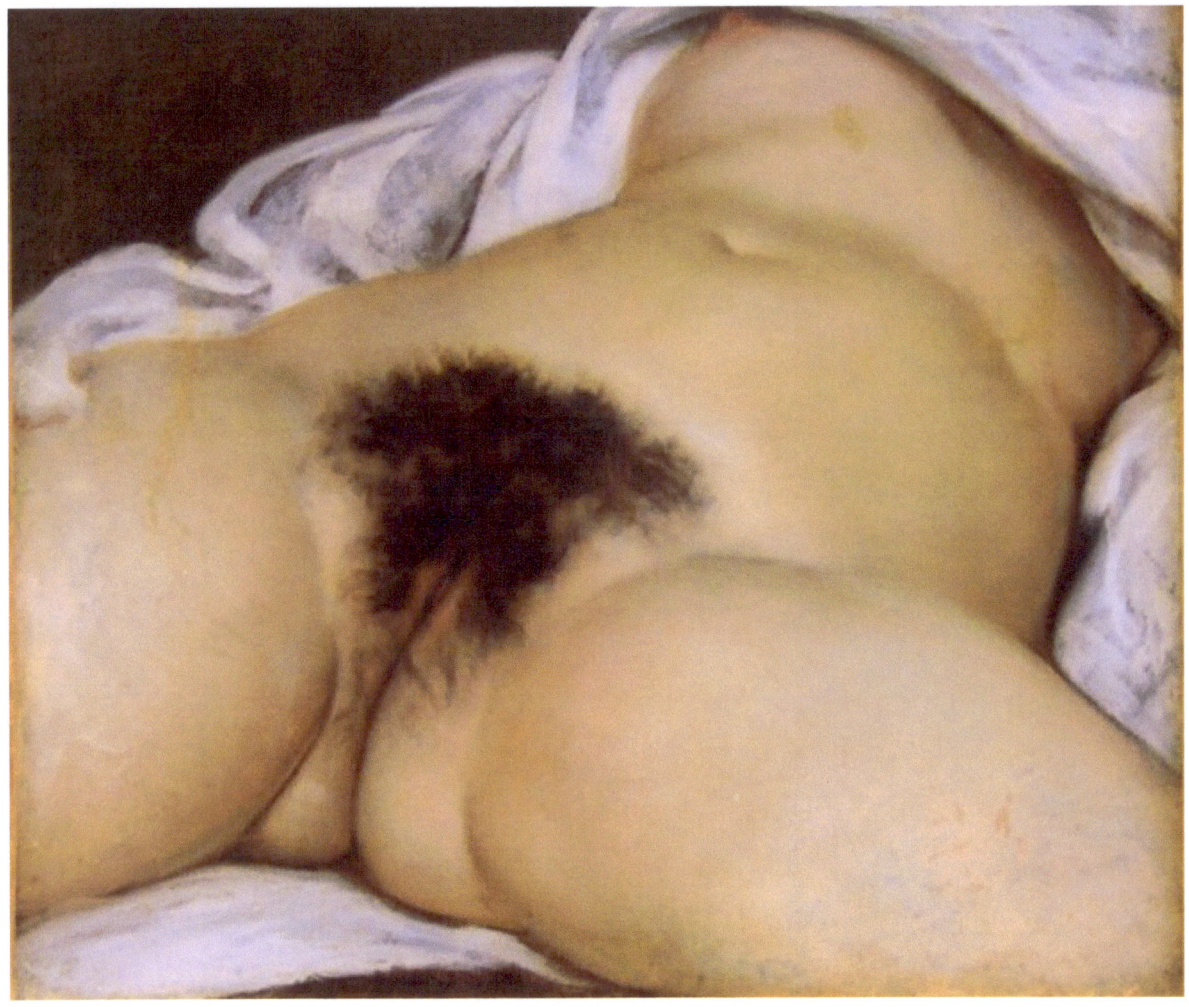

The Origin of the World --1866
Realism

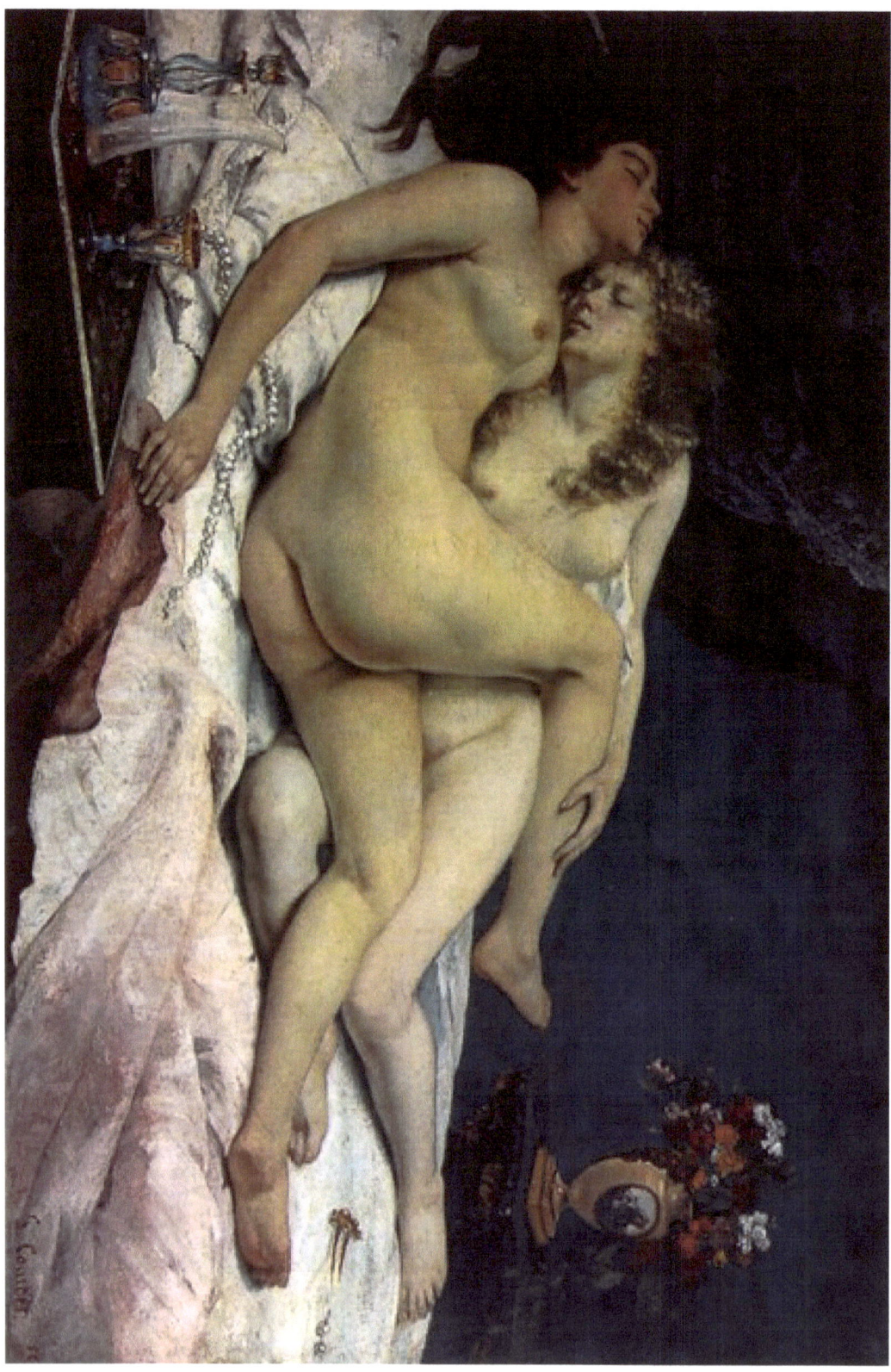

The Sleepers -- 1866
Realism

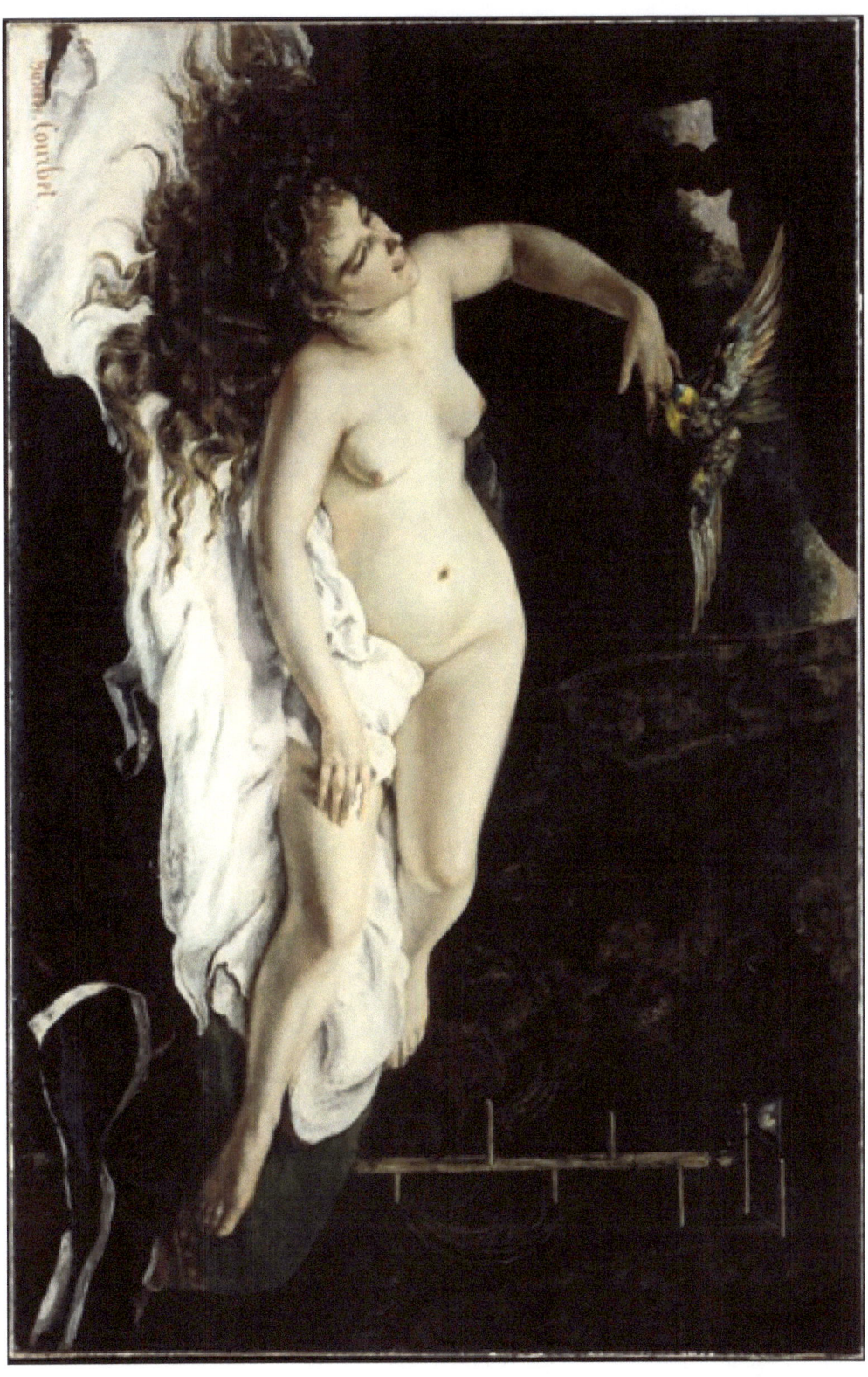

Woman with a Parrot

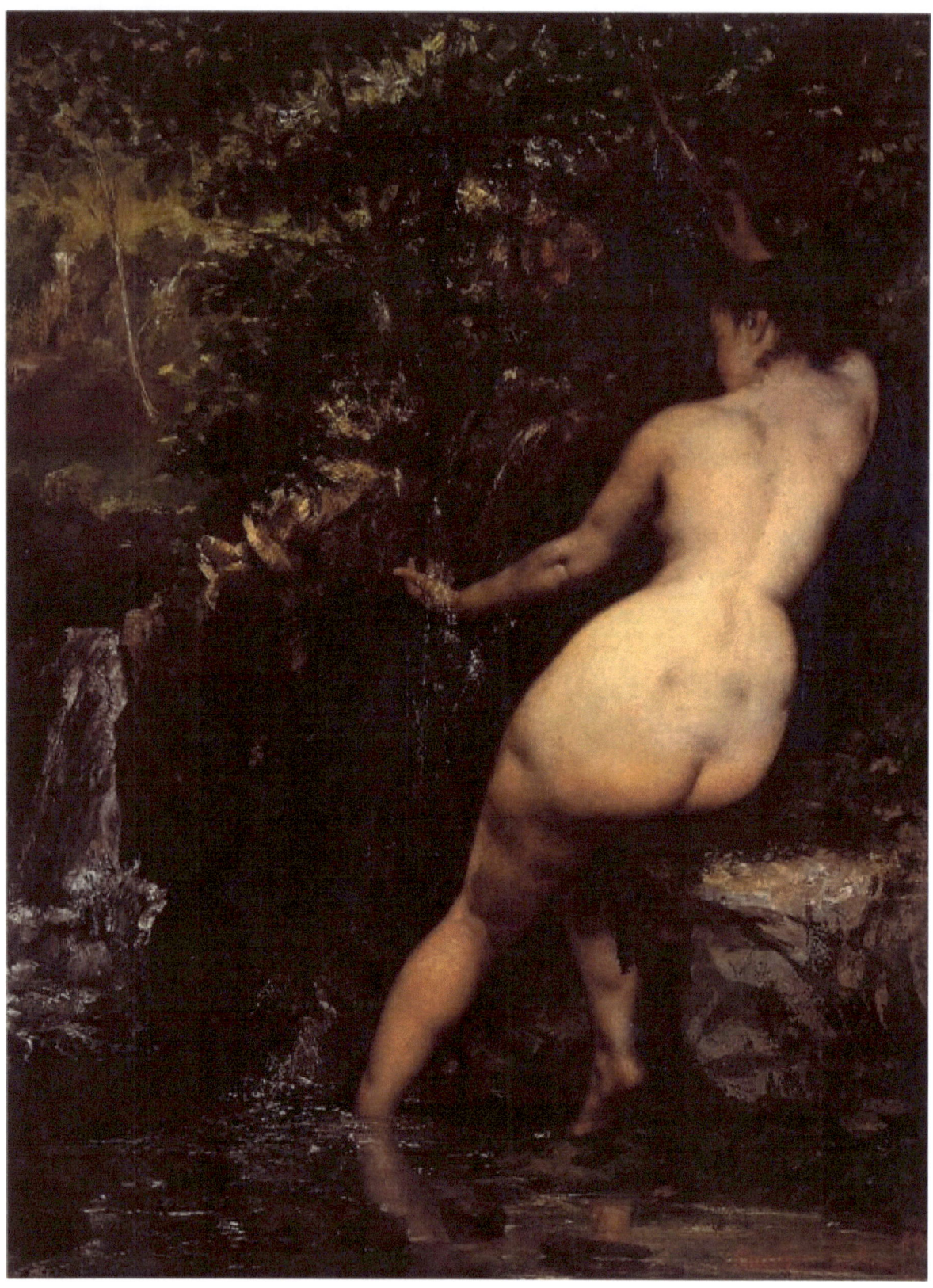

The Source (Bather at the Source) --1868

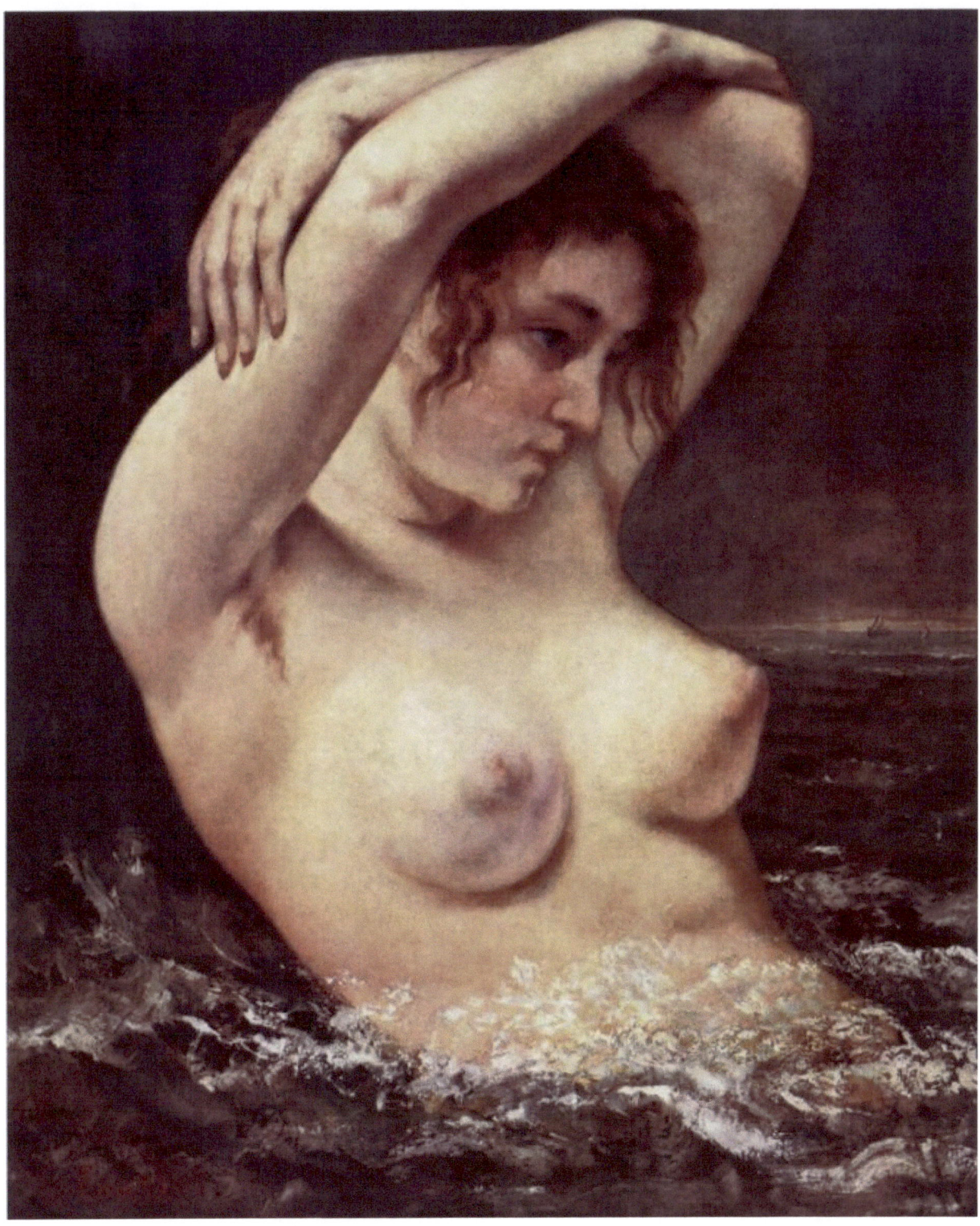

The Woman in the Waves (The Bather) --1868

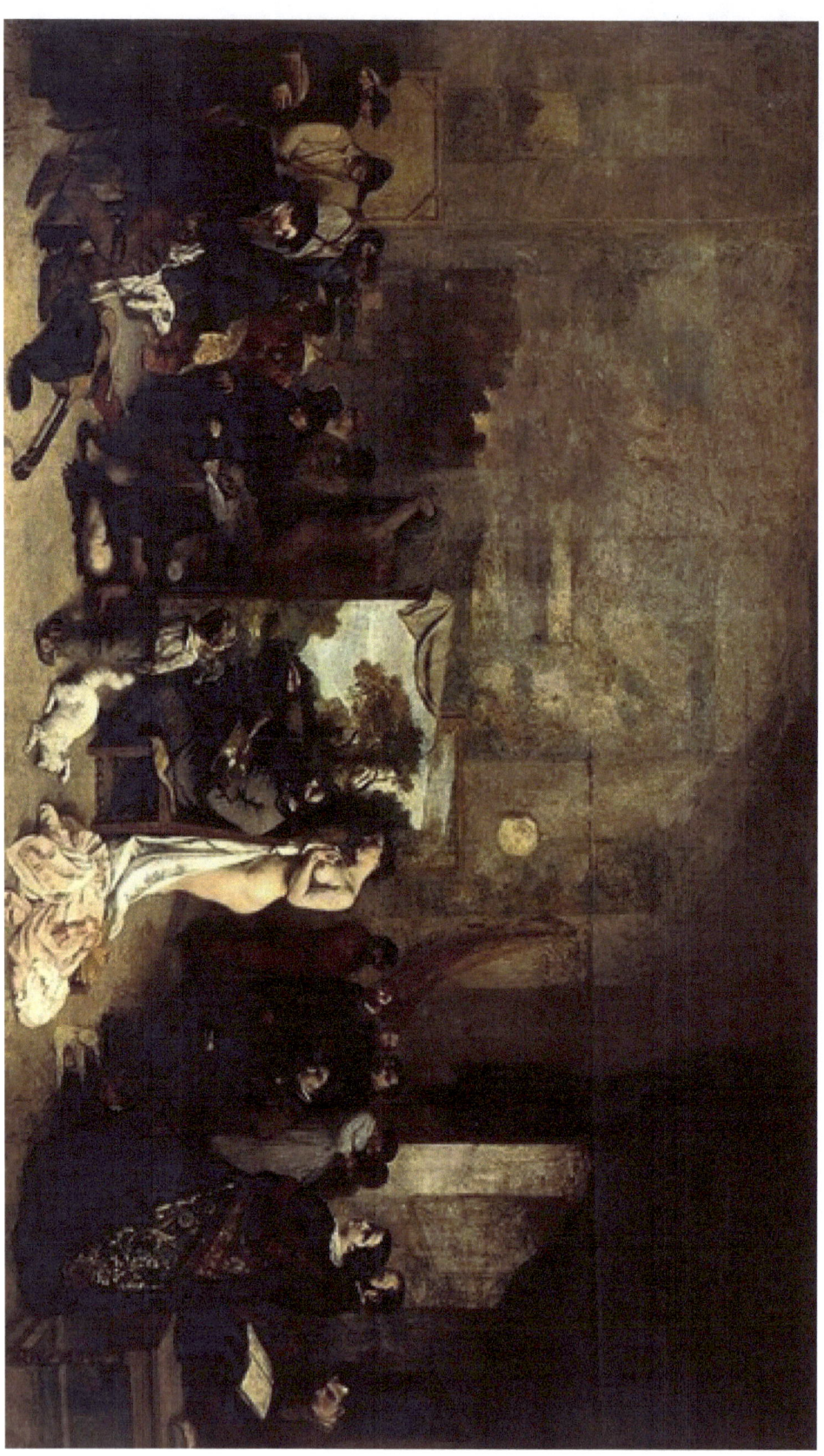

L'atelier du peintre—1855